FACETS OF EROS

FACETS OF EROS
THE DRAWINGS OF CLAIRE WILKS

DAVID SOBELMAN

EXILE editions

Publishers of Singular
Fiction, Poetry, Nonfiction, Translation, Drama and Graphic Books

Library and Archives Canada Cataloguing in Publication

Sobelman, David, author
Facets of eros : the drawings of Claire Wilks / David Sobelman.

Issued in print and electronic formats.
ISBN 978-1-55096-824-8 (softcover).--ISBN 978-1-55096-825-5 (EPUB).
--ISBN 978-1-55096-826-2 (Kindle).--ISBN 978-1-55096-827-9 (PDF).

1. Wilks, Claire, 1933-2017--Themes, motives. 2. Feminism in art. I. Title.

NC143.W54S63 2019 741.971 C2018-904853-0
 C2018-904854-9

Published by Exile Editions Limited – www.ExileEditions.com
144483 Southgate Road 14 – GD, Holstein, Ontario, N0G 2A0
Printed and Bound in Canada by Marquis

We gratefully acknowledge the Canada Council for the Arts, the Government of Canada,
the Ontario Arts Council, and the Ontario Media Development Corporation
for their support toward our publishing activities.

Conseil des Arts Canada Council
du Canada for the Arts

Canadä

ONTARIO ARTS COUNCIL
CONSEIL DES ARTS DE L'ONTARIO

Ontario
Ontario Media Development
Corporation

Canadian sales representation: The Canadian Manda Group,
664 Annette Street, Toronto ON M6S 2C8 www.mandagroup.com 416 516 0911

North American and international distribution, and U.S. sales:Independent Publishers Group,
814 North Franklin Street, Chicago IL 60610 www.ipgbook.com toll free: 1 800 888 4741

for Rishma
as promised

"My vocabulary is my line seeking a form that will say
all that needs to be said, if you can read it."
—C.W.

I
INVOCATION[1]

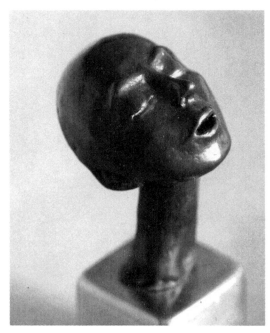

[1] Muse (bronze sculpture), 6.5 x 9.1 x 5.2 cm (1986)

Her voice
Alive in our gaze[2]

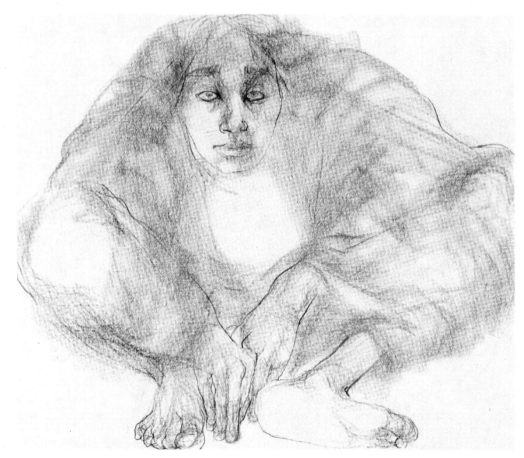

[2] A Voice Locked in Stone (1984)

In his retelling of the Greek myths, Robert Graves suggests that Eros, "hatched from the world-egg," was the *first* of the gods since, without him, none of the other gods could have been born.

In Plato's *Symposium*, Eros' greatest glory is that "he cannot do wrong nor allow it" and that "all serve [him] of their own free will."

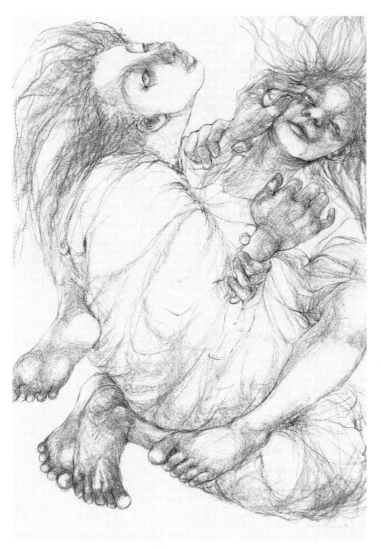

A white emptiness, a negative space, a surge of emotive lines, two female bodies, mesmerizing faces, one looks wounded, clasping the arms of the other in a prayer of supplication, two Conté crayon figures afloat in a momentary suspension of disbelief.[3] What Claire's hand saw leaves me pensive, absorbed, engaged in the suffering of the souls in their solitude, even as her line, her visionary line, performs an erotic dance, capturing the intensity of agony and desire in its starkness, capturing the joy of betrothal and the wretchedness of betrayal, capturing the moment when two dancers display the desire that is in all of us – to touch and be touched and become one in a celebration of life.

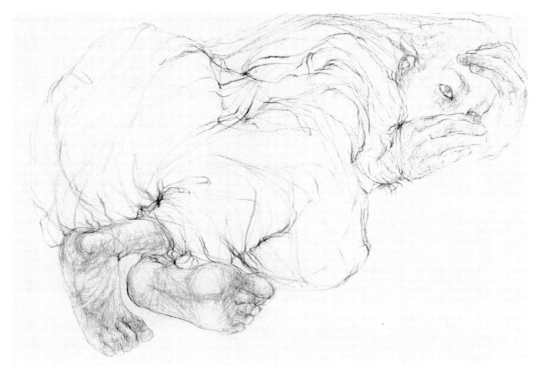

⁴ I Lie Cocooned in These Stories (1985)

What follows are notes and observations – not random but in response to individual drawings – based on being a literary dreamer, a frequent guest at Claire's table, a guest who broke bread with her at her Sullivan Street altar of singularity and sophistication, who drank the wines her man, Barry, poured into our blue glass goblets, and who was inspired by the observing eyes in Claire's drawings.[4]

II

TWO OF US TOGETHER: EACH OF US ALONE

Eros, the Intermediary

"Here, art dominates, art as purifying as fire."
—Baudelaire

I met Claire in 1983, shortly after her first showing of *Erotic Drawings* at the IGA Gallery on Queen Street in Toronto. I was a television producer at Citytv and had been invited to lunch, along with my co-producer, by Claire's companion, Barry Callaghan, at their home on 69 Sullivan Street.

She had prepared the meal in the morning before going to work. All Barry had to do was turn on the oven. As these repasts became a regular occurrence, I was often amazed by the way Claire balanced her work in current affairs at the CBC during the day, her planning and hosting of large literary soirées, which they held regularly, and her work at night in her studio on the third floor of their home.

Toward the end of our first four-hour lunch, Barry invited us up to Claire's studio.

What he showed us was an arresting series of twenty large, sexually explicit Conté crayon drawings of men and women *in flagrante delicto,* caught in the act. Each depicted a moment of sexual intensity, of lust and desire, and I remember thinking, *Eros is come alive in these drawings.* Eros, that figure of delight and menace, whose qualities have been part of our culture since Socrates praised them in Plato's *Symposium.*

The first drawing was of a woman about to be taken from behind. The male figure had no head. He was all torso, shoulders, and hands.[5] Initially, I remember laughing and thinking of the vision as a satirical moment, but I was wrong. As Socrates would have had it, this was, ontologically, Eros as a forceful intermediate presence in the moment, mysterious because he is there, between love and sex. An effect that is found in all her work, and one of the facets of Eros I shall circle around as I reflect on the beauty of these drawings and how they charged my emotions.

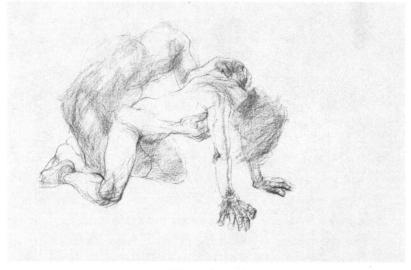

[5] Untitled (1982)

Note: To my exegetical imagination, these drawings[6] are totally removed from anything bordering on the pornographic and are clearly the work of a mature *draughtsman* wrestling with light and its shadows, with the essence of line and form, and in so doing providing each of her characters with a "beauty drawn from her own temperament" (Stendhal).

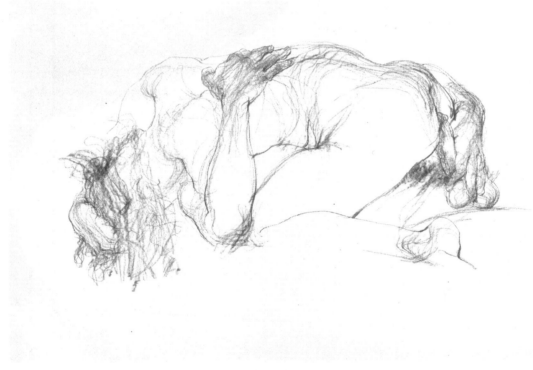

[6] Untitled (1982)

As Barry kept separating images from a seeming mound, my sense of the mysterious pull of Eros increased. The positions on the page – obviously as old as human history – not only suggested the tiny, energetic God in all his aspects, but they also had a startling freshness about them, as if Claire, the divorced mother of four

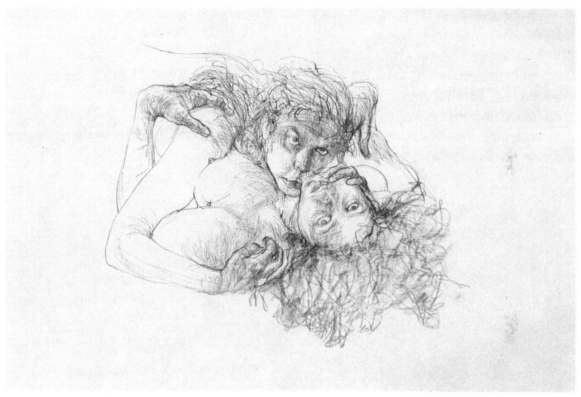

Untitled (1982)

adult children, was discovering in each of her drawings not just a revelatory way for women artists to "see" sex and sensuality, but the beauty of sexual passion in itself, aroused anew in her imagination.

Drawing: I saw two women staring at me while having sex. A dark-drawn face on top, looking straight ahead, *looking at me*, wide-eyed, preoccupied, angry, filled with panic, not sure whether to attack or take flight; and a lighter face on the bottom, watching me from *upside down*, her head anchored in dark curly hair, her calm, curious eyes catching me, the voyeur, by surprise.[7]

I have since come to call this experience, for want of a better phrase, Claire's *characterization* of the moment.

Barry then showed us a drawing of a couple engaged in *soixante-neuf* (horizontally),[8] and I realized for sure what I had only intuited earlier – the story we were being told by these drawings was one of revelation as an intimate presence. They disclosed a *self-containment, free from landscape,* which rendered the beauty of Eros rather than an evocation of the sexual.

In other words, each drawing is not a story "seen" (or told) in the subject matter but in following *the energy of the lines* – the energy of their formation, detailed and suggestive, an impactful energy that fuses around the

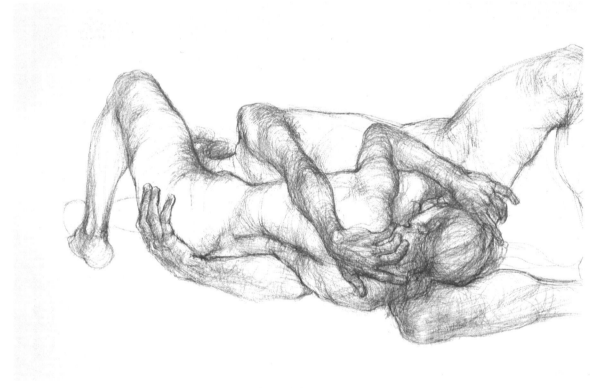

[8] Untitled (1982)

hands as she has drawn them, drawn their will to hold and be held, and the effect is charged by the negative space that acts as complementary counter to the often coarse elegance of those clutching hands.

There is great beauty in this drawing – a beauty that is in all the others, too – a beauty in *the appearance* of the intertwined bodies as "sculpted" diagonals, as form across the page, as bodies alone and together *as one in space.*

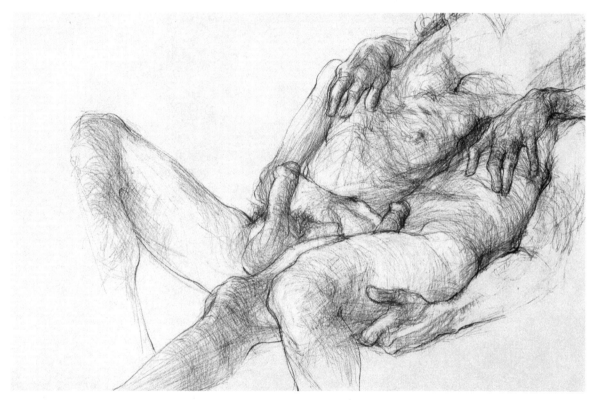

⁹ Untitled (1982)

We turned to a drawing of two males, each with an erect penis, sitting side by side, appearing relaxed, and gently resting on each other's torso.⁹ Both penises are meticulously cross-hatched and rendered with an objective

precision, as if to say, "Don't think of these phallic shapes as instruments of sexual passion, but see them as an erect form of beauty in their own right." Also, note that the men's heads are, once again, outside the frame, and their hands are completely central to the image, *describing* the reality of desire itself.

After some reflection, I came to believe that the story being "revealed" in these drawings is about *entering* the realm of polymorphous desire through the visual sense.[10] As Timothy Findley wrote in his introductory

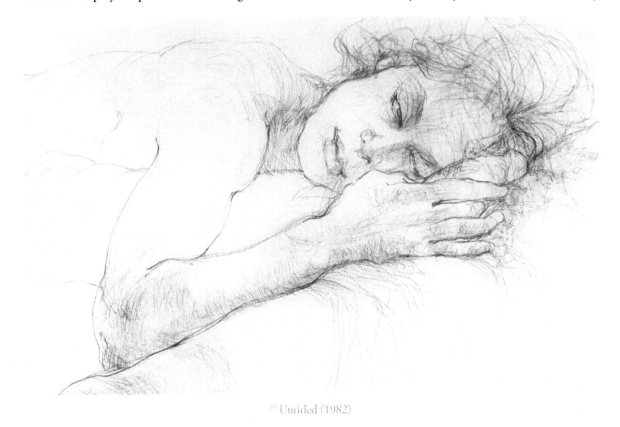

[10] Untitled (1982)

note to the boxed edition of *Two of Us Together: Each of us alone*, "Looking at these drawings, women are going to know what it is to be a man: men are going to know what it is to be a woman. Nothing greater can be

achieved but that we enter into each other's flesh through one another's eyes. This is the ultimate compassion – to hold and be held with fingers not our own: to be the flesh of others – held in another's hand."

All the poses in *Two of Us Together: Each of us alone* are representational, and direct, and in that sense refer to an Apollonian ethos (as opposed to the impulsive, emotional appeal of the Dionysian referent that the next series, *Tremors,* will reveal).

I've been told that Claire used models in *Two of Us (*Barry being one of them) and that the difficult poses she "engineered" forced her to work to the moment (the models could hardly "hold the pose" for more than half an hour). Looking up close at details in each of these drawings reveals the artist's deliberate study of an erotic object, as she sees it in and of itself. "It is what it is," or, to quote Baudelaire, "…the first quality of a draughtsman is the slow and sincere study of his model." Unmediated study – the immediate grasp of relationships, the weight of one line against another – is obviously evident in these drawings: they appear to my mind like *musical études.*

Around six in the evening, Claire usually returned home to Barry from her demanding work at the CBC (where she was chief visual researcher in current affairs for Canada's investigative TV programs *Weekend* and *The Fifth Estate.* On her studio wall are an Oscar citation and three Emmy citations).

As a man who rejoices in feminine beauty, I was always delighted by Claire's regal entrance. She walked into her smoke-filled kitchen, where we had spent the afternoon, and didn't say a word about the dishes, the empty bottles, or the cloud of cigar smoke that hung in the air. Instead, she sat down, kicked off her heels, and joined the conversation. On the one hand, she was an old-school, hard-boiled, classy dame and on the other, a natural chatelaine, reserved but with curves and great "gams" – "racehorse legs," as Barry liked to lovingly tell her.

As we talked about Claire's work, I noticed her long, thick salt-and-pepper hair and vivacious green eyes. Her ears, which I could see when she laughed or pushed her hair back, were suited to the dangling earrings she liked to wear. These highly colourful sculptural ear ornaments would not only draw my eyes along her neck to her shoulders but also remind me that she was a strikingly attractive woman not given to self-censorship.

One of the first notes I wrote about Claire's work dates back to December 1983:

Because she portrays the mood behind sexual desire (sexual passion), the figures she draws don't "show" themselves to the viewer, but invite the viewer into their subjectivity, *into their interiority, through suggestion, gesture, tone, and effect. And that is frightening because it points to one's own private sexuality.*

What I hear reflected in some people's comments about Claire's work has little to do with her work and mostly to do with their attitude to the erotic, and to Claire's sensual presence, which is, of course, evident in her work.

Many of these drawings of bare bodies without a landscape or background (drawings that have their own *raison d'eros*) are disturbing. They remind us that Eros is not only engaged in a constructive–destructive dynamic – what Freud called "polymorphous" sexuality, that is, a sexuality that is not limited to procreation or genital pleasure – but is also an *eroticism* that reaches for pleasure across the *whole of being*. As such, Eros is also a liberator of sexual passion, a passion that cannot only "lose itself" in the madness of lust but also in mystical love. The English aesthetician Roger Scruton called this side of Eros "a trapdoor through which the unsuspecting fall to their ruin."

"I had found a love letter…a love letter to Barry, a couple of letters, from a good writer. I looked at this and I couldn't stand it, and I suddenly became the voyeur. So, all that series, the *Tremors*, which came before the *Hillmother*, was a release for me. I had to do these drawings as I read the descriptions of what they did together and how they felt together. It wasn't like it was a technical textbook or something. I just read between the lines in their relationship. I sat there and did a whole series of drawings in which I am the voyeur. Sometimes I am the third person. Maybe sixty drawings. And then, I went on, and from that point I was released. The tyranny of the model was gone. I didn't have to hope that someone would come by that I could draw. That's it. It was freedom. I went on immediately and did the Etty drawings. Freedom."

—Claire, in a conversation recorded just before she died

III

TREMORS

Eros, a Diamon

*"The structure of the dream thoughts is in the regression
...broken up into its raw material."*
—Freud

The art of drawing is as old as the images found in the cave of Altamira. But the tradition of visual artists *thinking* with their hands, developing and expressing ideas on paper, only began during the Renaissance. Since then many an artist's black lines on a white page have had the immediacy of thought-in-action.

Claire's second series of "erotic drawings," *Tremors,* takes a leap into her imagination, as she draws her thoughts, her emotional reactions, her live impressions with the passionate abandon of a mad lover.

Continuing to use what will become her preferred paper size of 99.6 x 66 cm, with *Tremors* she foregoes the use of models and unleashes a series of stunningly spontaneous images that don't hide their impulse to immediacy, as if to say, "Here it is, as I drew it, and it's all I want to say about it for the moment."

Tremors amplifies Claire's emotive language as pure characterization. She explores and exposes the utterly naked, utterly physical reality of a couple's passionate sexuality. Line, light and shadow, hands and feet, are once again body language, but with a difference – the poses in *Two of Us Together: Each of us alone* show a restrained, self-disciplined, Apollonian ethos, but the stark, sometimes wild, and highly imaginative drawings in *Tremors* are entirely Dionysian.

The first observation that comes to mind is, I have rarely encountered erotic desire in its fierce complexity tackled so honestly.

Before delving into *Tremors*, let me provide some context: *Eros is also a diamon* (an otherworldly spirit).

Tremors shows us an "irresponsible Eros," as the Greeks called him, because he brings not just pleasure and pain to our lives but also – in his wild-boy aspect – a flagrant disregard for social order and puritanical convention, which is, according to Robert Graves, the reason Eros was not allowed to become one of the twelve ruling gods on Mount Olympus. Whatever his mythic genealogy, for the pre-Socratic Greeks, the wild-boy *Eros* was *the* primordial god (*protogenos*) of procreation, *the* driving force behind the generation of new life in the cosmos, a primal being hatched from the world-egg, an equivalent to *Thesis* (Creation) and *Physis* (Nature), a power not to be toyed with.

The *Tremors* series is *not* a series of drawings rooted in Wordsworthian emotions recollected in tranquility. It approaches our primal erotic forces, writ so large in our small lives, unrelentingly. *Tremors* is passion filled with rage, humiliation, regret – not for the sake of such emotions in themselves but in the service of a couple's wrenching rapprochement.

The backstory: After reading another woman's love letters written to Barry, Claire invokes the spirit of *Eros the diamon* to inspire these works, and to provide them with an authentic sensibility. In effect, these *demonic* drawings, these *tremors,* denote an artist's courage *sans* fear, and reveal, as the backstory itself shows us, how committed Claire was to stretching her own drawing experience.

Incidentally, Claire and Barry's deep and complex loving relationship continued through forty-seven years. She is reported to have told a close female friend a year before she died, "My life is Barry, Barry is my life," and after her death, Barry's dedication in his *All the Lonely People: Barry Callaghan Collected* reads: "To my Crazy Jane [his playful name for her], who at age 83, left me too soon."

Now look at this *Tremor.*[11] A man has penetrated a woman. Her legs are up, both her feet are flying in air, as if she is balancing his pelvic fulcrum.

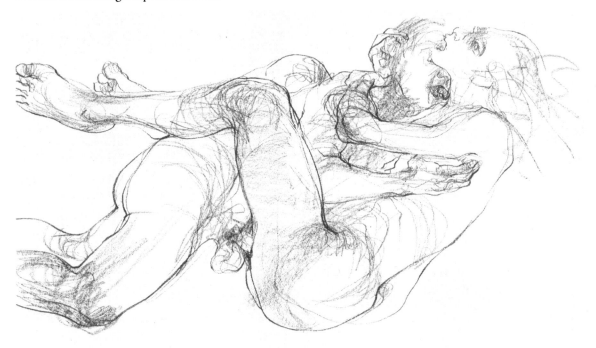

[11] Untitled (1982)

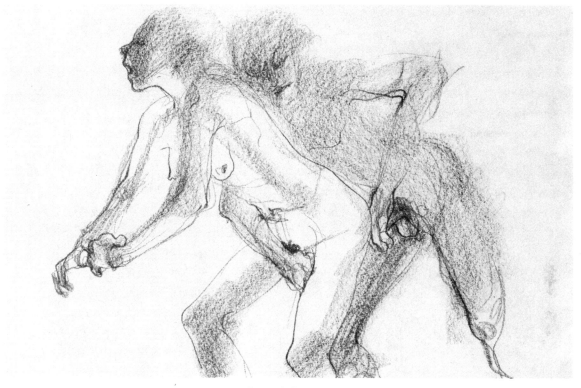

¹² Untitled (1982)

The man is licking the woman's neck, his hands seem to be reaching for a grip under her arms.

Her mouth appears to bite-kiss the man's forehead, and her eyes, wide open, stare into space.

The couple, as object, appear to be floating in space; they are all we see on the page, drawn in clear thick lines; our eyes are not allowed to be distracted by anything else, as if Claire is saying, Eros is energy, pure unadulterated energy; the very same energy she uses to draw her subjects and reveal *her own Eros,* inherent to her passion for drawing per se.

And look at this,¹² the shadow of a naked man, barely defined by a few dark-drawn shades, taking a woman from behind. The woman's face indicates surrender while the man's expression – hinted at in a haze

of shadows – is preoccupied with guiding his penis into the woman's derriere – into her anus or vagina we don't know.

The couple leans into each other, exuding a momentary pleasure. My point is the story is told "in pose." We see the woman's ambiguously open mouth, as if she's expressing a satisfying "ah," while her hands are suspended and floating freely in front of her. But it is the man's frowning, absorbed, barely suggested facial expression that reminds us of the hunger for "instant gratification," which Eros sets out to satisfy.

During *Tremors*, Claire "captured" five or six of these madly inspiring drawings each day. (Apparently there are forty more of these that I have never seen, which are now identified in her *catalogue raisonné*). It's this energetic urgency, which she sublimates into the flow of her lines, and into the dramatic expression of her figures' faces, which appears to me otherworldly, diamonic.

Gradually, what is revealed is a mood narrative developed in each composition and augmented by the pristine way the artist has framed each composition on the page. It's integral to *Tremors'* brilliance. The actions are without doubt overtly sexual, but the characterization is tender, suggestive, incomplete, as if the artist is showing the viewer how she felt while drawing it.

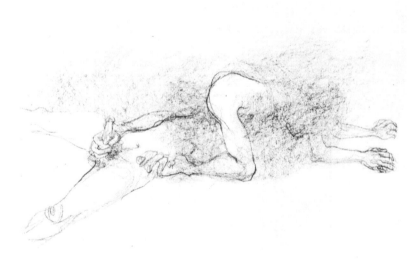

Look at this *Tremor*.[13] Again, the composition suggests an encounter in the middle of empty space or a dream-like nowhere, or heaven. *Clearly the subject is the pleasure found in the execution of this drawing.*

A man is flat on his back, legs spread, massaging his penis and a woman's foot. She's on top, covering his chest with her vagina.

What I feel is merely hinted at, since what I see is shaded.

[13] Untitled (1982)

The outline of the couple's bodies shows their legs and hands and leaves the rest completely cast in a charcoaled shadow. Again (because it is a key to Claire's talent actualized), the object appears to be sexual, but the subject is an artist's aesthetic execution, a suggestiveness of something she cannot say *but* by drawing it.

The next drawing: a man and woman hanging on to each other; notice the triangular, sculptural composition. The lower end is the base of a pyramid; the embracing bodies its apex.[14] The lines of the woman's body, as well as her hands firmly tied around his neck, express a loving, *needy*, attachment, while the man's rough,

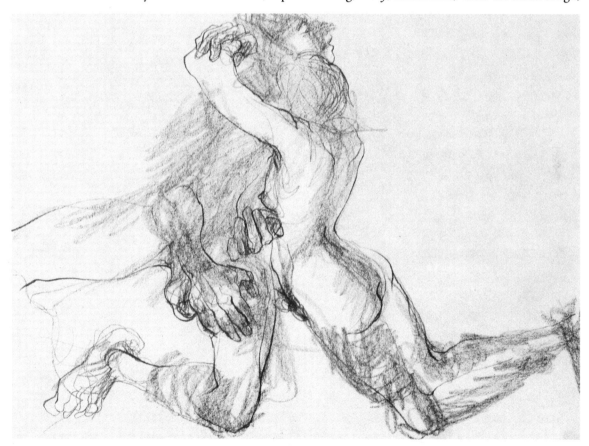

[14] Untitled (1982)

roots-like hands appear to be resting on his thigh, and his head seems to be looking elsewhere, as if he's there in body but not in spirit. As sketchy as his face is, it reveals a faraway intensity.

I have looked at the man's expression under a magnifying glass. It's so suggestive, yet so tentative. In close-up or medium close, this drawing is emblematic of the artist giving expression to the diamon inspiring *Tremors*.

In effect, each *Tremor* emotes a silent sexual pose attended by a mood of desire, anger, fear, confusion, bewilderment, concupiscence, et al.

A woman kisses a man's anus.[15] Yet the most revealing aspect of this drawing is the raw energy drawn into his feet and her hands, and the way they intertwine.

Here again, Claire's unique visual vocabulary supersedes the drawing's radical simplicity, which is the genius of *Tremors*.

The next *Tremor*[16] is a masterpiece of joy, of erotic suggestiveness, partly because of how the figures step up and dance out of frame right, leaving the left part of the frame as the space into which they can dance.

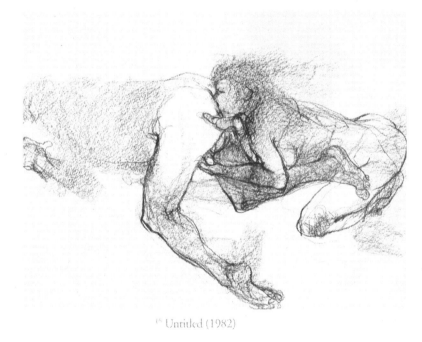

15 Untitled (1982)

Claire's vivacious sense of humour is visible in this naked couple waltzing through the frame. Her right foot kicked up, high in the air, as in the can-can, and her left hand pulling his head toward her lips for a kiss. The drawing is sparsely outlined, except for her right hand and his left hand tied in a sculptural knot, clearly interlocked for the dance. It's imbued with the strength of Claire's touch, focusing the viewer's eye on the dancing

motions rather than the naked dancers. A sublime drawing, symbolizing the strength of the feminine in a dance setting.

Claire's feminine strength appears even more clearly in the next drawing.[17]

A woman sits on the "ground" (which is implied by her pose), her legs apart, she's contemplating the contours of her vagina. There's a kind of calmness to this drawing that comes from a barely suggested look on her face. Her left foot is slightly, insecurely, turned in, and both her hands – one resting on the knee, the other holding her thigh –

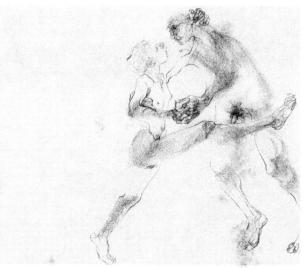

[16] Untitled (1982)

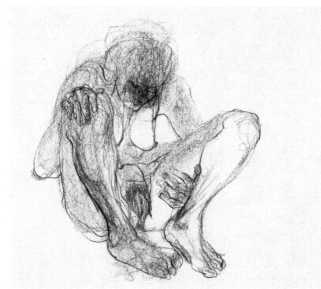

[17] Untitled (1982)

appear to actively balance our view of the dynamic between the woman's face and her capacious pudendum, the object of her feminine meditation on the animal-body/rational-mind duality within her own being.

Finally, I'll isolate two more drawings.

In the first, we see a naked woman riding her lover's back. Her hair is flying, implying both her freedom and (by the look on her face) a kind of witchcraft.[18]

Her hand, however, is in his mouth like a horse's bit between his lips, as if she's steering him.

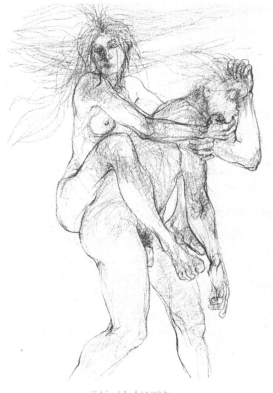

He is bent forward by her weight, his right hand points down, as balance, but also as if saying, "Come back down to earth." His left hand holds his head (like he is trying to figure out why in God's name he ever agreed to carry her, his burden). The image suggests a humorous, satirical flair without being funny or cartoon-like, and bears, like all of Claire's drawings, her observer's eye.

A last *Tremor:* A man taking a woman from behind, his body a shadow, barely outlined but for his hands (*of course!*).[19] His eyes are closed; it seems like he's relishing penetration. The woman's right hand is up in the air, balancing the composition. Her left hand holds his thigh, yet her body and the look in her eyes suggest surprise.

And the drawing's placement on the page! As if the sexual act occupying the right side of the frame seems to need all the empty white (or negative) space in front of it to breath.

As a whole, *the Tremors series is tremulous*. It quivers in its chiaroscuro suggestiveness, not to arouse (or titillate) but to characterize the moods we experience in pursuit of sexual pleasure. Here, the viewer is invited to see Eros, *the diamon*, and to feel the artist's sophisticated view of him.

Object and subject are drawn together as the essence of desire. *Tremors* is short on detail and rich in emotive sensuality. To paraphrase Baudelaire: *in these drawings the artist foregoes detail in order to capture essence* of the high–low, comic–tragic emotions we experience around the sexual act.

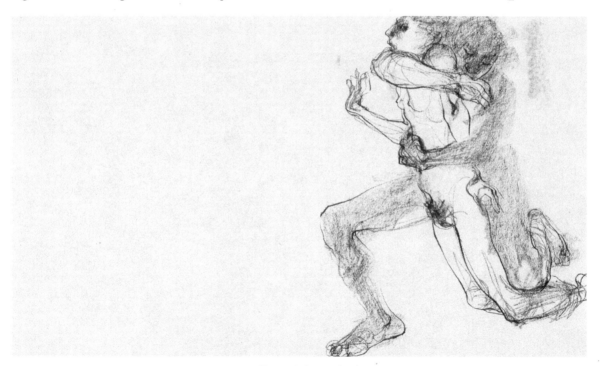

19 Untitled (1982)

IV

HILLMOTHER

Eros, a Mythic Inheritance

Mother. Earth. Birth.

I look at the drawings in *Hillmother* with a sense of wonder, like a child marvelling at the images holding his gaze.[20] (I shall discuss this stunning drawing on page 42 because context must always come first.) I will, of course, never know what it physically feels like to give birth, but I know when something astonishes me. *I was stunned into silence* the first time I saw one of the large Hillmothers, serene babies streaming out of a gigantic woman's vagina.[21]

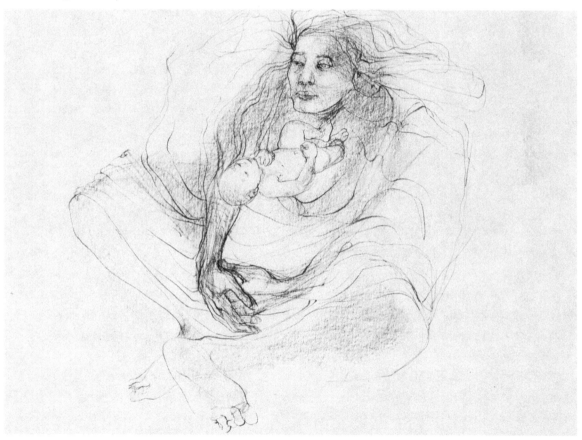

[20] Untitled (1983)

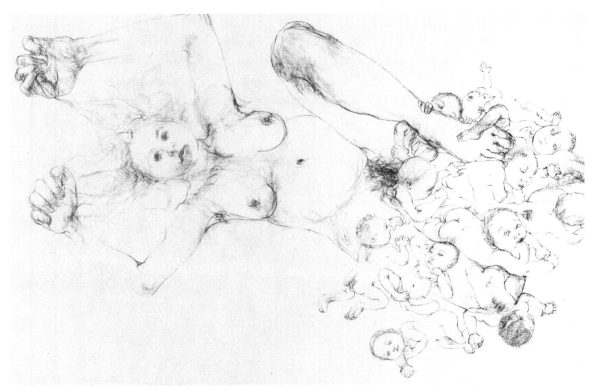

A similar swarm of babies float up and around a mother's belly and torso and up to her shoulders, where two are asleep peacefully.[22] There are perhaps thirty or so such babies, full of infantile innocence, and not one of them is crying or laughing, which adds a strange air of tranquility to this mothering colossus, sitting astride, projecting and protecting her offspring.

The look in her eyes, as well as the overall image, is imbued with an epic sense of confidence and strength, generosity and abundance. This is monumentality. Her darkly outlined hands and feet (a motif we once more recognize as one of Claire's grounding characteristics), her flowing long hair, frame this unnerving vortex, a vortex that suggests a goddess, or a mythic daughter of Eros, contemplating her fate.

The fate of being a mother, and of motherhood writ large, confronted me anew in one of Claire's most mysterious Hillmothers – a fantastic two-headed, four-handed, two-legged surreal image.[23] I hardly knew what to think, and felt overwhelmed by its grandeur. What was this, a fecundity dream or an elaboration on the

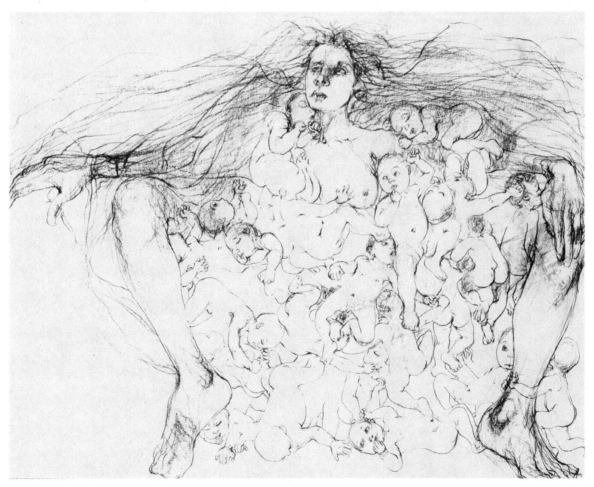

22 Untitled (1983)

Gaia-like magnificence of motherhood? The overall feeling in this drawing is one of benevolence. One female face appears at ease in a soothing, contented sleep, the other steadfast, committed, extending her protection to a hill of wide-eyed babies, innocence as a force open to the world. Central to the drawing are the two females' hands bound together, radiating a strength and a trust. Was I looking at a Janus-headed *gestalt* of motherliness?

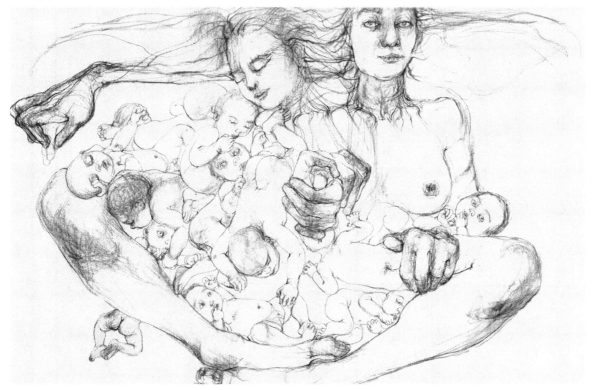

Untitled (1983)

Or was this, by its very nature, a view of motherhood as an eruptive sharing of life, life in all its holiness? Was I looking at the Two Faces of Eve? Or the Blessed Virgin and the Mother of God as One? Or, perhaps, the surreal, serene mood in this drawing was capturing the mythic Eros of motherhood per se?

These drawings, these Hillmothers, are to my mind extraordinary visions of maternity. I know nothing like it. What could be at the root of it? Well, a few months before she died, Claire answered that question (to a degree) in conversation with her Israeli cousin, Shira Richter, herself an artist, filmmaker, and feminist.

One day in Cuba, I'm sitting on the beach and I hear a couple giggling, and then I hear whining and kvetching, and baby noises, and the couple are saying, "No, no, no, it's all right." And I turned, and looked, and there were two lovely women with a little kid that they're burying in the sand. And they are laughing, and I went into a horror because of the Holocaust. I thought…they're burying this kid and thinking they should laugh and I remember at age fifteen in the foyer of my high school, a young man was brought in…brought in from Germany…straight after the war, in the 1940s. And he had all of us standing there listening to what he was telling us…and asking him questions: "What was it like?" And he said, "We, when they buried the children alive, the whole world screamed. The whole earth screamed." And that was the basis of my *Hillmother* drawings…I am giving back life.

Giving back life. On what terms?

The answer to that question (again to a degree) lies in an epigrammatic poem by the Irish poet John Montague, "For the Hillmother," a poem she attached to her publication of the series. A choice, and a gesture, suggesting that, for a secular Jew, Claire had a deeply religious sensibility.

> *Hinge of silence*
> *creak for us*
> *Rose of darkness*
> *unfold for us*
> *Wood anemone*
> *sway for us*
> *Blue harebell*
> *bend to us*

Moist fern
 unfurl for us
Springy moss
 uphold us
Branch of pleasure
 lean on us
Leaves of delight
 murmur for us
Odorous wood
 breathe on us
Evening dews
 pearl for us
Freshet of ease
 flow for us
Secret waterfall
 pour for us
Hidden cleft
 speak to us
Portal of delight
 inflame us
Hill of motherhood
 wait for us
Gate of birth
 open for us

The imploring tone of the poem – in the manner of a litany, suggesting the sacramental – introduces the viewer to Claire's radical discourse on the emotions of motherhood. But, before attempting to say something about the drawings, who might this Hillmother be?

She is certainly no Esther, no Judith. Nor is she Bathsheba or Jezebel. Why did Claire so readily attune the drawings – at least in a rhetorical way – to an Irish legendary figure?

Perhaps because she had had an experience with that landscape and its feel, its evocations, its myths. Though I am only guessing here, she had travelled through the southwest of Ireland, still so primordial in its way, and I know that until she died she often spoke of wanting to go back to those hills, the hills of Danu, also known as Anu, the Celtic goddess, from whose body all of life had emerged, a life of *abundant fertility*, regeneration, and nurturing.

In the West Region counties, Claire, driving into the hills with Barry, discovered, to a satisfaction she said she felt in her bones, two side-by-side hills known as the Paps of Anu, their crests surmounted by mounds of stones, which – when viewed from a distance – make the hills resemble a woman's breasts, nipples erect.

Also on this trip, Claire became aware of the *Sheela na gig*, an ancient female figure that can be seen sporadically – if one is looking for her – throughout the countryside, a female figure, an earth-woman carving, cut into stone and set in monastery and church walls – always staring brazenly out at the world – sitting with her legs spread wide, displaying a large vulva, which she is holding open with both hands, open to entry, open to be feared, open after birth…

In this very particular landscape, fed by the Gulfstream and mildly "tropical" in its way, Claire encountered monumental trees, lush in their growth and fed by huge roots, which she – as she stood up against them, as she embraced them – came to see as akin to hands, her own hands as she had drawn them upon the page, a mother's hands, reaching down to her own earth in strength and rootedness.

Finally, in this Celtic world, she learned that the mythic women are all powerful, independent forces; they are warriors, Epona is the goddess of the horse; they are lovers who take their lovers by will, they seem to have children with abandon. They are the great mothers, the very land is in their shape, the Paps. Not surprisingly, given all this, there are no men or masculine figures in Claire's *Hillmother* world. There is a complete absence of Logos, the opposite to Eros. The Eros *outed* here is completely feminine and – indicative of Claire's psyche – *a personification of her being, a woman, a mother, an artist,* "giving back to life."

These perplexing, often disorienting, drawings speak in a rare way to the third context in which Eros appears in our lives; that is, through mythic legacy, which can mean a family trait, a cultural tradition, or a genetic characteristic, or as the driving force behind the generation of new life in the cosmos. *Hillmother* contains the light and shadow side of this third aspect, identifying Eros with the power to create and give birth.

In this respect, Claire's drawings challenge, first, our understanding of the mythic life force of motherhood, and, second, they give us some perspective on the "power and powerlessness of maternity," as Anne Michaels has put it.

Unable to possess any truly intimate awareness of birth and mothering, what am I, as a man, to make of these images of power, and possibly anger, present and presented in these works?

At best, let me say something about one or two of these drawings by asking some questions.

I have looked at this particular drawing a hundred times (see image page 35). It stops me cold. It moves me to *think* about the mother–child bond *anew each time*. We have a woman who is wearing a contemplative gaze, her hands folded on her lap. Hanging *serenely* in mid-air – at a perpendicular angle to her chest – a perfectly drawn baby.

The impossibility of its perspective arrests.

The effect is disorienting.

It appears like an ethereal juxtaposition that just doesn't make sense – unless I read it as a symbolic expression of the anger that can enter the mother–child relationship. It may look like she wants to throw the child away, but she hasn't, she doesn't, she keeps a fierce hold on the baby.

Every helpless baby, figuratively speaking, *stands* on a mother's chest, as they do in their first year, before actually beginning to walk. But *this standing baby* is airy *and* aerial; he possesses a disturbing gravitas that leads me to ask, "What in Claire's experience could have possibly motivated her to render the deep ambiguity in this situation?"

A squatting Hillmother[24] cradling a baby in her arms. She sits in a pure white surround, an egg-like oval darkly outlined, suggesting her body is the baby's only protective shell.

Earthy, cupping hands enclose the baby's stare, which is pensively fixed on his mother. She is not looking at him, she is staring into the space ahead. A query inherent in that pose made me search for an answer – until I realize that the answer I am looking for is not to be found in a single drawing but in the series as a whole.

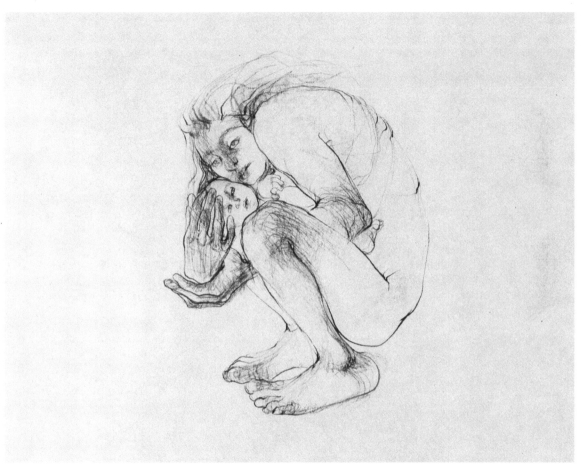

It seems to me that Claire's habit of work, through series after series, engages in *variations on a theme* because her emotive language requires a serial continuity to be seen (or "read") properly.

Like her other series, *Hillmother* strikes me as a symphonic work in that certain of its emotional motifs, like a refrain, recur in their variations. As a man, I am of course fascinated by these mothers, and revel in their

fecundity, but at the same time I am aware of dark, conflicting emotions. Unquestionably, the artist has captured the good, true, and beautiful of motherhood, but it is the intimation of a darker side that arrests my mind.

Consider the energy in the madness of this.[25]

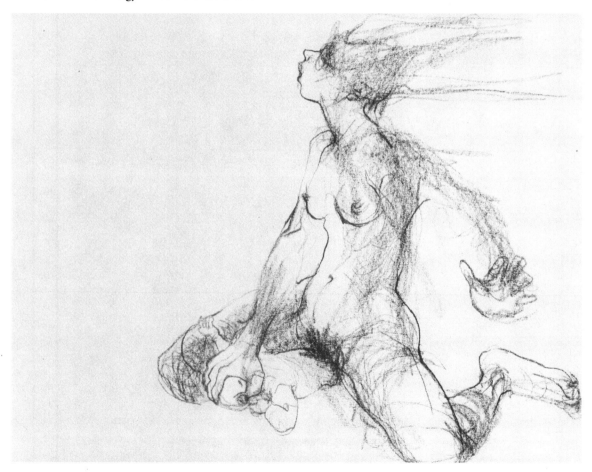

[25] Untitled (1983)

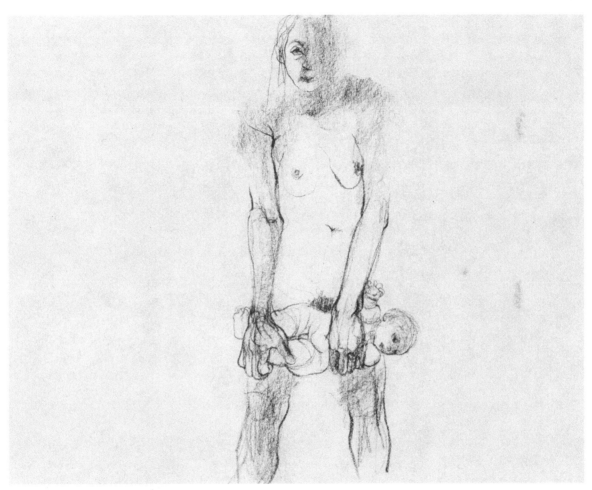

Is she trying to suffocate the baby, or push the baby back into her vagina, or is she pulling the baby out?

And then there's a naked woman who is holding a baby as if it's an inanimate object.[26] Both hands hanging down by her pelvic area hold a child as if it were a club.

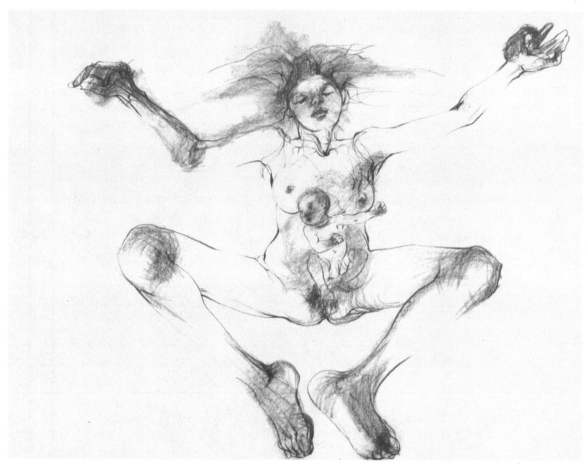

Untitled (1983)

The child's face, however, is alive, looking down as if nothing is wrong. Its tiny hand is reaching upward, perhaps waving, perhaps indicating that it doesn't matter how sorrowful life appears to an adult, to a baby it's all new, it's all just as it must be, and that, too, is part of the Eros of life. This drawing's arresting presence reveals the depressive side of motherhood and, as such, tends to authenticate the fertile, light, joyful side of birthing[27/28]

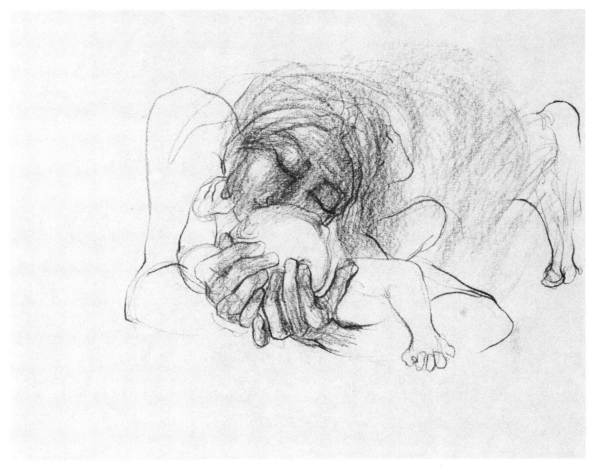

²⁸ Untitled (1983)

as seen in several of the other drawings – drawings in which the mothering goddess appears as a natural child-bearing organism.

Along these lines, as always, with Claire's distinctive slant on life, we have a drawing[29] in which a regal woman has apparently returned to a dreamy sexuality, perhaps some months after childbirth. Her figure, realized

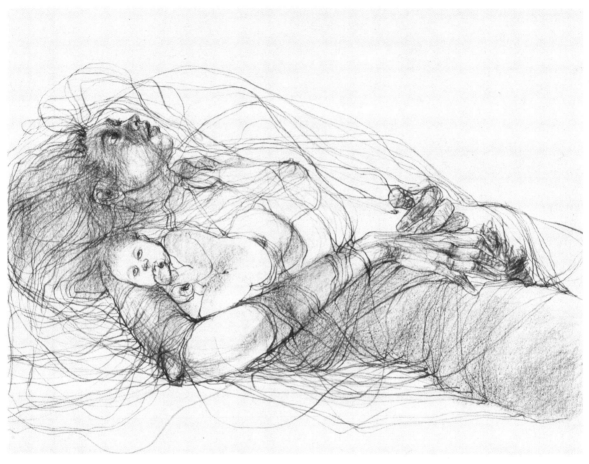

in sensuous, sinewy lines, holds in her arms a contented baby, sucking its finger, while she masturbates. The woman seems to be fully aware of the baby in her arms as she engages in her sexual fantasy. This astonishing portrayal conveys an Eros that's present in the sanctuary a child finds in its mother's arms, as well as its mother's ongoing erotic desire for sexual gratification.

Irrespective of these questions and speculations, there is an imposing grandeur to the *Hillmother* series, a grandeur that defies interpretation, like the mystery of motherhood per se.

And so, I step back again, quietly, and face terror, fear, resignation,[30] again, and the hope for resilience, again, as I board a train bound for the death camps…

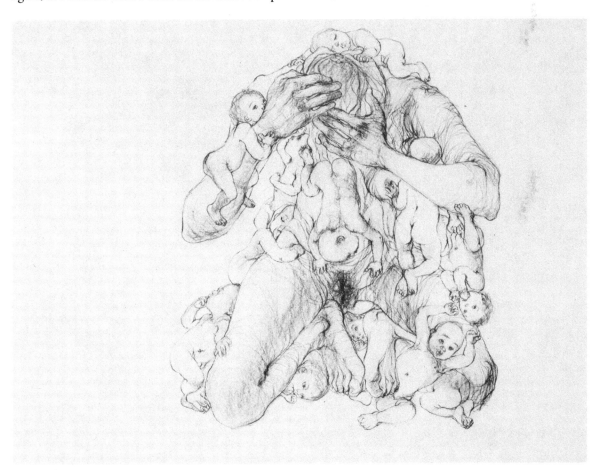

[30] Untitled (1983)

V

THE THINKING HEART: THE ETTY DRAWINGS

Eros, the Tormentor

"We should be willing to act as a balm for all wounds."
—Etty Hillesum

Our journey to the camps begins with a sublime drawing, *Just an Ordinary Jew.*[31]

Why begin with this drawing?

Because at the time that Etty wrote it ("There now, you're just an ordinary Jew, aren't you?") – before Zionism took over – most ordinary, secular Jews considered themselves citizens of the world.

But before delving into the drawings themselves, allow me to take you into the heart of the subject behind this stunning, unnerving, shattering work of art.

Representation of the Holocaust in the arts has been a contentious issue since – just after Hitler's war – the cultural critic Theodor Adorno announced that "to write poetry after Auschwitz is barbaric."

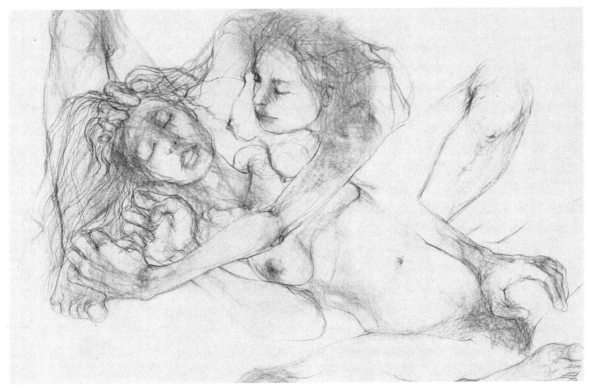

¶ "Just an Ordinary Jew" (1985)

Adorno spent the rest of his life expanding, explaining, and qualifying this statement, adding finally that "suffering...also demands the continued existence of the very art it forbids." But the essential issue he was pointing to has remained essential. Adorno was using the act of writing poetry to amplify the tension between ethics and aesthetics inherent in any artistic production, but especially one concerned with the genocidal barbarism that took place during the Holocaust.

Though Claire had not read Adorno, and frankly cared not who he was, the Etty drawings are in effect, ethically and aesthetically, an original, intensely focused artistic response to Adorno's statement that she presents first as a visual text, and then through the drawings' titles, which derive from and send the viewer back to *The Thinking Heart*'s literary muse, the diaries of a Dutch Jew, Etty Hillesum.

From the beginning, Claire had amplified her view of Eros, the life force, through the use of literary epigrams, aphoristic introductions, or poems. The appearance of her work in galleries had been blessed by a statement of defence (as a counter to the priggishness on the part of local poo-bah ladies) by the painter William Ronald, poems by the Serbian poet Miodrag Pavlović, an assertion of approval by novelist D.M. Thomas, *The White Hotel*, and the poetry of Barry Callaghan. In *The Thinking Heart*, however, she chose a muse woman for inspiration.

Twenty arresting drawings emerged from Claire's close reading of Etty Hillesum's two Holocaust accounts, *Etty Hillesum: An Interrupted Life (the Diaries 1941–1943),* and the remarkable record of her spiritual growth under Nazi pressure, *Letters from Westerbork.*

The Thinking Heart drawings, or the Etty drawings as they've come to be known, are the creative result of Claire choosing to go deeply into Etty as an alter ego. I think this not only because several drawings have a sentence or a phrase from Etty's diaries attached to them (these are identified by quotation marks around certain titles), but also because specific scenes in Etty's writings anchor and inspire every tragic, emotive moment in the drawings. Moments that pierce the heart with their curvilinear vocabulary.

Writing is a linear language, it aims at a clear, logical perspective. Drawing is a circular language, it has no beginning and no end, and everything within its outlook is simultaneously in the moment and timeless. Although drawing, of course, is so much older than writing, both art forms are intimately connected to memory.

Both are dependent on line; both put pen to paper, so to speak, but the line in one is called the sentence, and its beauty depends on the writer's ability to recall the meaning of words, their relationship and their resonance; and in the other, the line's beauty depends on how the artist draws and shapes an object's contours. Both render images to be perceived. Drawing takes our primal conscious into the realm of pre-orality, whereas writing aims to translate our experience of the environment into contemporary language. Both are in pursuit of a memorable image or impression – be it visual or verbal – but only writing can draw upon reason to contemplate, appreciate, resonate, praise, moralize, or even criticize the silent, hermetically sealed speech of drawings. And to do that, to make ideas clear, and visual, the writer uses linear vocabulary to convey the meaning of the curvilinear vocabulary the artist invented.

Like Hillesum in her diaries, intent upon engaging in and revealing her burgeoning spiritual awareness and compassion in the face of Nazi barbarism, Claire in her *Etty* series contextualizes Eros, *the tormentor*, and, in the process, achieves a pure actualization of her silent artistic *Self*. In effect, the great subtextual accomplishment of these quintessentially Jewish drawings is the way they deal with *a dark truth buried*.

Hidden away in the hearts and minds of Jews who survived (because they didn't live on the war-infested continent or because they are children of camp survivors born right after the war) is an inherited responsibility to remember. We were imprinted with the gravitas of the suffering endured during the terror of *Shoah*. We were lucky, as long as we remained vigilant and did not forget. "Never again" was the key to our dark truth buried. Buried by survivors at the bottom of our secular Jewish identity, it became our dark side, the shadow of our identity, which we cannot escape. Each of us was traumatized in some way by a survivor's guilt, and we each had to find our own way of dealing with it, of ensuring it would never happen again. But because it happened elsewhere, to other Jews, on another continent, or because it happened before we were born, it became a guilt, the guilt of living, which, like original sin, we couldn't completely come to terms with.

That's what makes Etty Hillesum's diaries such a remarkable achievement – she's not an innocent, precocious Anne Frank – she's literate, she's sexually and intellectually engaged, she's an inquisitive woman in her twenties – and what she does brilliantly is find the words:

At night, as I lay in the camp on my plank bed, surrounded by women and girls gently snoring, dreaming aloud, quietly sobbing and tossing and turning, women and girls who often told me during the day, "We don't want to think, we don't want to feel, otherwise we are sure to go out of our minds." I was sometimes filled with an infinite tenderness, and lay awake for hours letting all the many, too many impressions of a much-too-long day wash over me, and I prayed, "Let me be the thinking heart of these barracks."

Etty was an emancipated Jewish woman (1914–1943). She came from an assimilated background and lived her short, liberated life in Amsterdam. Her diaries describe the hateful Nazi occupation yet remain a paragon of emotional and intellectual detachment and growth.

Her letters, however, written in Westerbork, a transit camp for Jews en route to Auschwitz, are a heartbreaking record of dignity cut off at the knees. Etty faced it. She wrote about it, the horror, the moral terror, with consummate grace.

These letters, written during her internment, are crafted in *a language all her own*, a language that depicts what she saw. The Nazi occupation first, of course, and then having to wear a yellow *Jood* star, an abuse of her mind, her sensibility, and, ironically, an amplification of her need for spirituality, which she writes about until she was murdered by the Nazis in Auschwitz, 1943. She was barely twenty-nine.

Many would agree, there is no one quite like Etty Hillesum in the realm of Holocaust literature, just as there is nothing quite like Claire Wilks' *The Thinking Heart* (a.k.a. the Etty drawings) in the archives of Holocaust art.

Both women, each in her own time, appear ahead of their time in the creation of works each *needed to do, to define their character*, to be human in the face of Adorno's "genocidal barbarism."

In that light, considering the subtext, I shall apply the drawing's titles as *interstitials* to reveal Claire's alternative narrative.

Our journey began with *Just an Ordinary Jew*. It is a striking composition that *freely* resonates with another great work, Michelangelo's *Pietà*. In the *Pietà*, the seated Virgin Mary holds the lifeless body of her son in her lap. In Claire's drawing, a young, naked Jewish woman's head is cradled between the squatting legs of another

naked, compassionate woman. She seems to be a maternal figure (like Mary) to the cradled woman in pain, whose right hand is resting on her own vagina while her left hand is wound tightly into a fist, as is the right hand of the woman holding her. There's a tension at work here – between the comforting empathy in their faces and the deep anger signified by their fists. The artist has caught several layers of feeling inherent in the crucifying agony of being an ordinary Jewish woman terrorized in a concentration camp.

To associate Etty's suffering with the *Pietà* may seem to be an awkward juxtaposition – the horror and degradations experienced by Jews and that allusive Christian desire – hope against hope for redemptive release – but Claire's choice of the pose, the artist's acknowledgement of this comforting need, is itself a sign of hope where there was no hope during the Nazi internments, and it lends this drawing a subtle, consoling quality (a quality also found in Etty's diaries).

Further, in *Just an Ordinary Jew,* Claire shows us that even under the worst conditions, even while on a train to a Nazi concentration camp, Etty's emancipated Eros, her tormented life force (and Claire's by association), has actually come face to face with its embodied reality – *contra* Adorno – wherein even the worst kind of dehumanization can spark *an irregular beauty.* That's *the fourth aspect* of Eros: the human condition into which we are born ignorant and are sometimes motivated by Love to recognize our unawareness, perhaps even come to know it. That's the Eros driving the Etty drawings. It is the most complex perception of Eros, an Eros of madness and of suffering. And this confused, tormented, barbarous, dark Eros of *Shoah* is rendered here as an *Algolagnia*, as the pleasure of art derived from the pain of life. It is the vivifying energy I find in these drawings, it is *the felt mystery* of actual pain amidst pleasure and actual pleasure amidst pain.

This fourth facet, like Aristotle's formal effect, is a sublimated, anguished, nightmarish convulsion of life against death, clearly seen in the stricken, fearful, yet not in themselves horrifying eyes found in Claire's *Transport Boulevard.*

Transport Boulevard [32] is inspired by a street Etty describes in Westerbork, the transit camp from which Jewish prisoners were transported by rail to Auschwitz.

Note the hair-raising bewilderment and panic on the faces of both women, the signification in the hands, one woman's pointing downward, as if trying to keep shock and fear grounded, while the other woman's hands

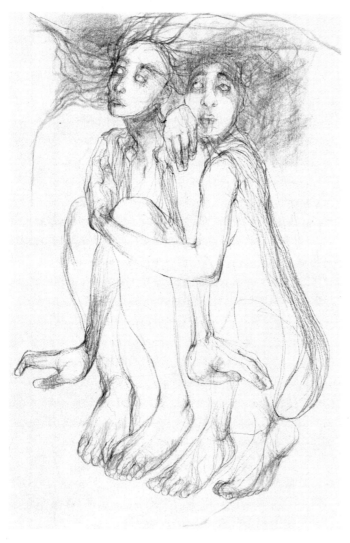

"Transport Boulevard" (1984)

are effortlessly resting on her compatriot in suffering, as if the artist wants to say, "A natural and casually bestowed compassion, a human kindness, is what separates us from monsters."

Ich Kann es Nicht Verstehen, Daas Die Rosen Blühen (I Know Not Why the Roses Bloom):[33] another view of Eros, the tormentor.

The two faces in *I Know Not Why the Roses Bloom* are compelling: sad-eyed, they speak of their inability to know anything with finality about the great essential mystery of life and death. To paraphrase Primo Levi, "One cannot, and what is more, one must not understand what happened, because to understand is to justify."

Which begs the question: If it's impossible to understand, if it is necessary *to not understand*, then surely knowing is essential, awareness of the historical facts is essential, because as history teaches us, we are doomed to repeat what we let disappear out of memory. What we don't understand can really hurt us, as the two women in that drawing reveal. They are hurt by what they know – but cannot understand.

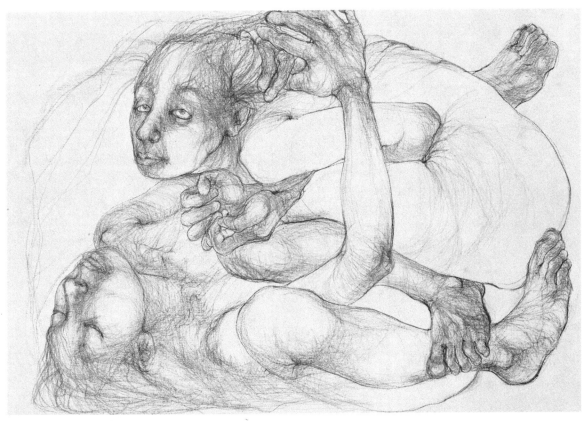

³³"Ich Kann es Nicht Verstehen, Daas Die Rosen Blühen (I Know Not Why the Roses Bloom)" (1985)

At this point, we can see that *The Etty Drawings* are not just about the past. By focusing her aesthetic matters on the physical emotions of victims, Claire ethically stretches the legacy of the Holocaust into the future, rendering the consequences of what Robert Burns called "man's inhumanity to man" as devastatingly of the present.

This is the perplexing bewilderment found in *Vortex*.³⁴ A maelstrom of hands, feet, female faces. One looking out, stunned; another inquisitively looking down. The third staring up. The three together, physically

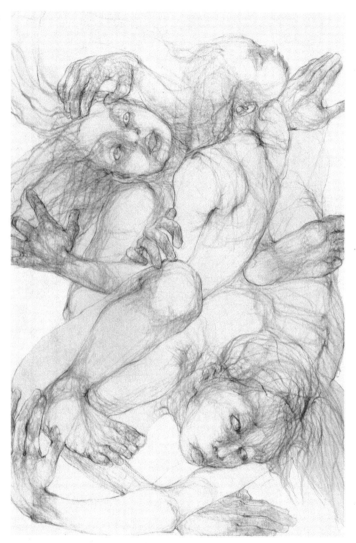

Vortex (1985)

intertwined, a human vortex. But these are not the three Fates, dancing in a meadow on the island of Ithaca. These figures signify a dreadful disorientation. Behind these entangled bodies, each emoting in a different direction, there is a sense of distress, fear, and resignation; a turning around, a looking back for signs of help.

The ground from which *Vortex* rises, as described by Etty, is an overcrowded barrack in a transit camp. As indicated earlier, in her diary entry of September 15, 1942, she recognized herself as "the thinking heart" in that camp. But what could Claire have known about actual life in the claustrophobic barrack?

Only what had already been mediated through media and through personal encounters with survivors, like the one she had at age fifteen in the foyer of her high school, which upset her and stayed with her for the rest of her life. (I have learned that, as a current affairs visual researcher, she compiled a small collection of photographs taken in the camps.) As I look at this drawing, I am reminded that I wasn't there either, that I can only know the suffering through reportage on one level and

through art on a more profound, visionary level – through a thinking heart, through Etty in her diaries, generous in its expression, and through Claire in her drawings. They inspire me to find the right words to engage the disorienting whirl of life as I know it, as I live and suffer and trust it, revolving inside a media vortex.

> *"When I suffer for the vulnerable, is it not for my own vulnerability that I really suffer?*
> *I have broken my body like bread and shared it out among men. And why not, they were hungry and*
> *had gone without for so long."*
> —Etty Hillesum, *An Interrupted Life (the Diaries, 1941–1943*, 12-10-42, p. 230)

It is essential to understand that Etty's diaries were not motivated only by a need to give witness to the cruelty of the Nazi occupation but also by a need to search for emotional and spiritual meaning, to give witness to her internal world. This is also true of Claire's work, not just in *The Thinking Heart* but also in the earlier series of drawings, which render visible her interior landscape, the setting of her life force, the Eros of her art.

As a couple, Claire and Barry were internationally known as gracious hosts, often laying out sophisticated suppers and throwing large literary parties at their salon home. In this sense, Claire has figuratively, if not literally, broken her body like bread and shared it with many – myself included – while still climbing the three flights of stairs to her studio most evenings to draw and sublimate her singular feelings. A sacred ritual that was as integral as breathing to her life.

To again note the sacramental in this secular Jew, I turn to a grand work, a kind of altarpiece, a triptych centred by *I Have Broken My Body Like Bread and Shared It Out Among Men*.[35] The three panels together constitute an iconographic depiction of a clustered disorientation, feminine figures surprised in fear, confused, perhaps crying for help, braided in space – a space with no borders yet somehow detaining, confining – these women, bound together, *terrified* into compassion during a time of extreme duress.

Though all the Etty drawings have been shown on several occasions – in Toronto, Stockholm, New York, Jerusalem, and Oakville – the triptych, as such, has been – because of its size – shown only once, at the Canadian Clay and Glass Gallery museum (2013). It is obviously a monumental work. Its side panels extend, protect,

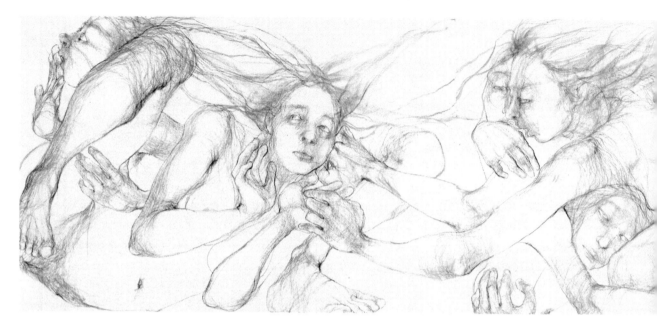

and comment on the three-metre-long central panel. Each side panel is a stunning, perplexing, sixty-six-centimeter-long drawing.

In the outer right side panel, called *There's Always Been a Splendid View from Here,*[36] we see a single, observing guardian figure. Her hands held up, her right hand indicates surprise while the left hand is turned into a fist. But it's her eyes that hold us with an accepting look that somehow manages to question the situation at the same time.

The outer left side panel is an unsettling rendering of two female figures.[37] One has the feel of piercing agony in her face, as the other turns her head up in what seems like supplication. The feet of the anguished figure are curled around the hips of the suppliant one, and both her hands are clasped to the arms of the supplicating figure, whose left hand is comforting the face of the wounded woman. There is a profound longing for succor in this powerful panel, which also stands on its own as *They Open Up Before Me.*

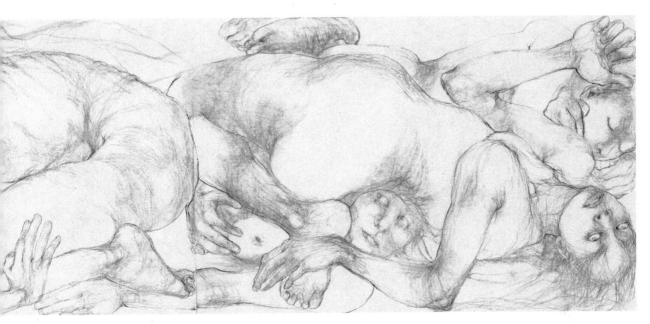

...d Shared It Out Among Men" (1985)

Generally, an altarpiece is an artwork representing some aspect of the redemptive mystery inherent in a religious subject. I don't think it is far-fetched to see Claire's triptych as a visual account of the mystery of *Shoah*, a mystery that can never be redeemed, for which there is no salvation, no closure, no understanding. At best the feeling eye, or the thinking heart, can travel from right to left or from left to right across the panels and realize there's no place to rest one's gaze. The tension between the resigned outer figure on the right and the questioning agony of the figures on the left does not permit it.

These three drawings together, and alone, are a clear example of the "principle of incompleteness" in Claire's works, an aesthetic principle in which *the viewer must also engage, must also participate*, if he or she is to complete the intervals, fill the gaps, get to the questions found at the heart of these images.

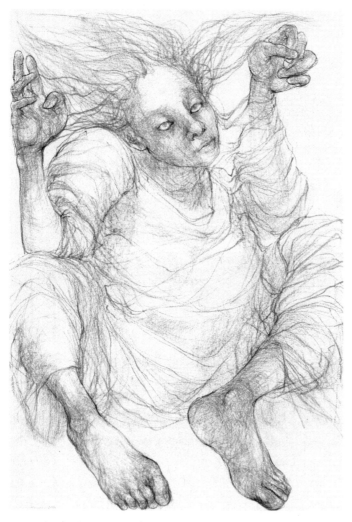

This aesthetic insistence that the viewer fill in the gaps, complete the incomplete, is evident in all of Claire's drawings, but finds its figurative "apotheosis" in this triptych, partly because the relationship between the three drawings is expressed mysteriously – in the way the triptych makes the viewer feel its complex Holocaust iconography. First, through the disorienting state its curvilinear narrative captures and, then, through its resonance with Etty's diaries, *An Interrupted Life*, visually suggesting its horrors and emotional disruptions. Like a variation on one of Gödel's incompleteness theorems, *I Have Broken My Body Like Bread and Shared It Out Among Men* invites the viewer to contemplate endless continuity as *its subtext*.

Note: I Have Broken My Body Like Bread and Shared It Out Among Men and *Jews in the Desert* are Claire's most totemic drawings. They further develop her recurring leitmotifs – female faces, agonized bodies, hands, and feet – into arresting grammatical elements of a visual vocabulary.

In both of these works, a mistress of her medium is drawing as if she were an

improvising jazz singer: each phrase (a figure) freely shaped in the moment and yet with its "end" tailored to fit the next figure (phrase), thus revealing Claire in her moment of inspiration, executing her temper, building a theme that grew in significance to her – the monstrous reality of *Shoah* as the defining event of secular Jewish life.

For many years, over many evenings, I have mused about the knotty bodies that emanate from the two female figures on the extreme left side of *I Have Broken My Body Like Bread and Shared It Out Among Men*. Its presence radiant over Barry and Claire's supper table.

The lower head feels decapitated, dissociated and loose, and many times, as the night wore on and the drinks kept flowing, its otherworldly beauty reminded me of a human horror that can never be explained but through distortion or *verzeichnen,* like the fractured poetic technique of Paul Celan.

At the same time, these finely drawn figures ripple and swell, like a wave of bodies and faces, across the frame, their

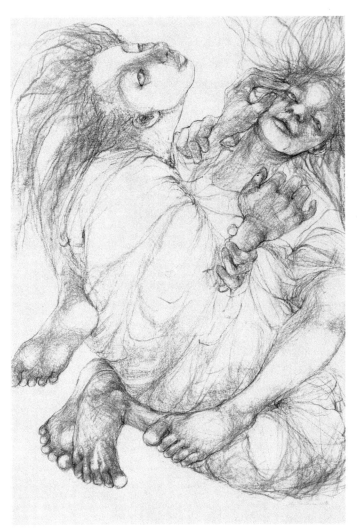

"They Open Up Before Me" (1985)

flow resonating with the intertwined lines that I recall from Klimt's tapestries and Moreau's murals, but without their decadent colour symbolism. Here, line and form flow and merge perfectly, leading the eye across and into the arms of the last female figure on the right side. This end figure, reminiscent of the female in *Transport Boulevard*, is half turned, looking off frame with a mystifying stare in her eyes. What is she looking at? The future?

The gas chamber?

Note: These bitingly stimulating drawings show no men, no Germans, no trains, no camps, no yellow *Jood* stars, and still they constitute an emotional bedrock of compassion in the face of actual horror, fear, panic, and the desire to survive, to live despite the Nazis and despite being considered the weaker (or second) sex. In effect, they show and remind us that cut off from men, from civilization, women survive by being emotionally available to each other.

A Small Silent Voice [38]

Read what Etty wrote in her diary one Friday evening in May 1942:

> Looked at Japanese prints with Glassner this afternoon. That's how I want to write. With that much space surrounding the words. They would simply emphasise the silence… A few delicate brush strokes – but with what attention to the smallest detail – and all around it space, not empty but inspired… If I should ever write – but what? – I would like to brush in a few words against a wordless background. To describe the silence and stillness and to inspire them. What matters is the right relationship between words and wordlessness…

That is Etty's inspirational voice. It led to this drawing of a troubled woman's silent *interiority* as she sits surrounded by a white space that emphasizes her silence. She's hunched, covered in a cloth or blanket. Her eyes are closed in pain. Her right hand holds her head, her left leans, resigned, on her bent and drawn-in knees. There is something so familiar, even classical, about this figure, yet she is fresh, even refreshing in her presentness.

Claire found her way of dealing with the buried dark secret that haunts diaspora Jews and the children of

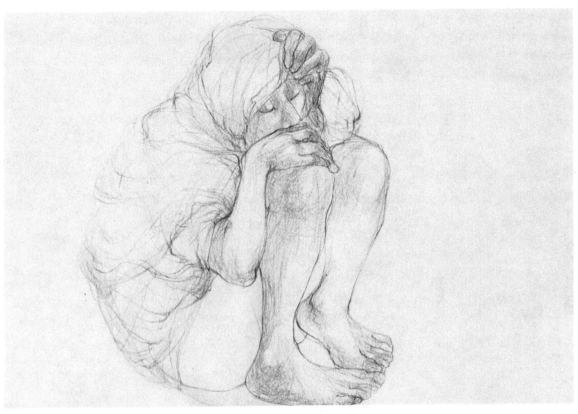

¹⁵ A Small Silent Voice (1985)

survivors when she decided to explore Etty's tormented, dislocated, "incomplete" world of enlightenment. In so doing, she became a secularized Jewish seeker, a deep diver, going right to the heart of modern Jewish aesthetics.

Jewish aesthetics?

Is there such a branch of philosophy?

Yes, there is! It is an *aesthetic* the Nazis had no problem identifying as the decadent, "erotically dreamy," abstract modern art of degenerate Jews. Ironically enough, "erotically dreamy and abstract" – as in the

accompanying detail from *Donnewetter, Some Flying Tonight* [39] – was also the critical accusation levelled by a *Globe and Mail* reviewer against the Etty drawings. Little did they know about Jewish culture or why it had been "imageless" until the early eighteenth century and the first secular Jewish emancipation from the media ecological prohibition of the Bible's Second Commandment:

> Thou shalt make no images for yourself nor the likeness of anything in the heavens above, or the earth below, or in the waters under the earth. *(Ex. 20: 4)*

Not being allowed to create any images of G-d or any other object on, above, or below the earth left the People of the Book with a rich trove of Talmudic interpretations, Yiddish literature, poetry, and music, but *no Jewish*

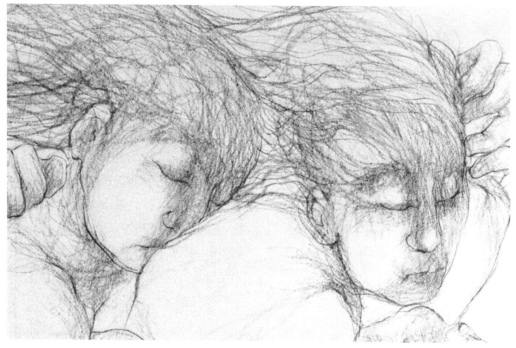

[39] detail from Donnewetter, Some Flying Tonight (1985)

painters. The Jewish "graphic arts" were strictly utilitarian, that is, only concerned with religious artifacts and literate illuminations of Passover *Haggadot.*

In other words, until the early eighteenth century, visual Jewish art was in the realm of what is called "arts and crafts" rather than being integral to the absolute and purely creative *l'art pour l'art.*

Incidentally, in a secular world, the absoluteness of art for art's sake is as close as one can come to the sacred.

The uniqueness of tone, intent, and effect of Claire's drawings in *The Thinking Heart* is not accidental, but in its style it is a culmination (or a "clearing," in Heidegger's terms) of a century and a half's worth of Jewish artists struggling to be true to their spirit.

To contextualize this "clearing" that Claire had to go through to arrive at the effect of her style, let me take you on a short, whirlwind tour of Jewish aesthetics. On this tour, consider me inspired by *She Stands There as if Spun in a Web of Horror.* [40]

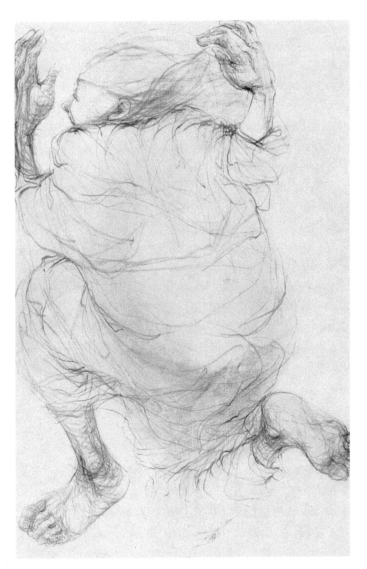

"She Stands There as if Spun in a Web of Horror" (1985)

Just like Claire's lines-in-motion in this drawing, through the strange pose of a female figure, seem to reach ahead and want to turn back at the same time, so will I take a few steps back to reach ahead and expand on the semiological referents that make the Etty drawings a quintessentially Jewish work.

Edgar Levy wrote about the "elongation" effect found in the art of another great bohemian Jew: "for Modigliani and by a modern paradox for most of us, *only a mask wears the features of the soul…in a world of unremitting pain* [emphasis mine]."

This masking to reveal the psyche, the soul, of the subject is one of the earliest tenants of the modernist revolution in art. A revolution that changed the Aristotelian principle of *mimesis* (imitation of reality) in favour of pure creativity. As Claire said earlier, "The tyranny of the model was gone… It was freedom."

In reality, as the Jewish aesthetician S.S. Schwarzschild wrote, the modernist perspective called for "the production [of an art object] not given by nature."

And strange as it may seem, this representation of what is essentially *aboriginal* is also an essential component of modern Jewish aesthetics. It was established formally in 1908 when *The Aesthetics of Pure Feeling*, a radical Jewish book on Kantian aesthetics, was published by Hermann Cohen, "Kant's Jewish avatar." It sets out to define the "ethics" inherent to Jewish aesthetics and ends with a paean to "impressionism" (then a revolutionary force).

Cohen articulates the historical context (the Great War and the Second World War) that led to a "necessary distortion," or *verzeichnen* (in German, *verzeichnen* means both "to note" and "to distort"), and moved the vanguard of painting toward works that express an imaginative impression of the artist's perspective. To my mind, this is the peculiar aesthetic we see in the drawings of *The Thinking Heart*.

The German Jewish impressionist Max Liebermann argued that capturing the essence through *distortion* was both modern and Jewish. In effect, we can say that the Einsteinian melding of space and time made the interior Spacetime of Chagall's paintings possible – just as the Freudian search for the meaning of dreams called for a new understanding of the "principle of incompleteness."

Rachel Wischnitzer inaugurated the first-ever Hebrew journal on art (*Rimon*) in 1922, and she also formulated a Jewish aesthetic divorced from "naturalism." Hers was an aesthetic based on a diaspora experience that is "distanced from the world of reality"; an aesthetic that is more concerned with the "inner face, the

inside of things" rather than its representation. Again, consider Chagall's *luftmenschen* or Modigliani's elongated figures; Arnold Schoenberg's highly abstracted, serial music in *Moses and Aaron;* Kafka's parables; Samuel Bak's paintings, his original visions of being a child of *Shoah* and growing up in DP camps; and then "see" Claire's Etty drawings again.

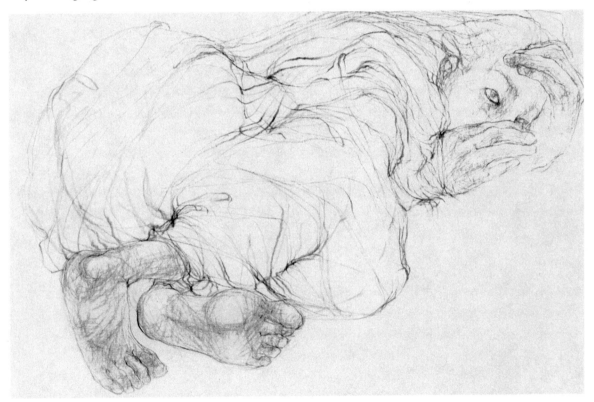

[41] I Lie Cocooned in These Stories (1985)

I Lie Cocooned in These Stories[41]

I was born in Haifa, Israel, to an old Jewish-French family that had lived and thrived in Palestine since the 1880s. In 1959 my mother married a Dutch Catholic Merchant Marine officer and we moved to Holland.

As diaspora Jews, especially those of us without Zionistic fervency, we are dependent on Schoenberg, Chagall, Modigliani, and the like. To us, Franz Kafka is not just a writer but an enlightened modern Jew who had the courage to put into open play the whole mystical Jewish edifice. That is, in a world bending toward the absurd, Kafka raises anew the question of meaning. But he does not provide an answer (another form of incompleteness) other than to suggest that asking the questions is the only way to preserve some semblance of sanity.

This modern way, this "shock of the new," as one famous art critic called it, simultaneously questions and revivifies those aspects of Eros that are embedded in Claire's emotive translation of Etty's writings. The clarity Claire achieves in each drawing is due to the relationships she established between the physical and the emotional (to paraphrase Spinoza), relationships that produced the look, the gaze, the mood that is her *visual emotive language*, a language drawn by the will of Eros, the life force that makes love, sex, and the passion for drawing possible.

As the father of modern art in Palestine/Israel, Mordecai Ardon is reported to have said, "All I am doing, as a Jewish artist, is making visible what one does not see." An apt description of those unmasked moments is encapsulated in Claire's figures, moments in which Eros is not only a driving, living energy but also, paradoxically, the living force that will not allow us to forget *Thanatos*, Eros's conjunctive opposite, the god of death.

Claire died on Wednesday evening, January 25, 2017. These days, afloat in the sorrow of mourning, I tend to agree with the diary entry Etty made on February 19, 1942: "I no longer believe that we can change anything in the world until we have first changed ourselves."

Could prayer ever be efficacious in such death-ridden circumstances?

Look at *The Girl Who Learned to Pray*. [42]

Two female figures stretch across the frame. The one on the bottom is withdrawn, contemplating her hands, as if thinking, Can this really be? Will putting my hands together in supplication really help?

The female in the upper part of the frame divides the drawing into two equal parts. Eyes closed, she is already inside her prayers. She appears in deep meditation. Her hands are lifted side by side, pointing upward in an appeal to God, the Divine Will or Savior. These long hands are a salt-of-the-earth version of Albrecht

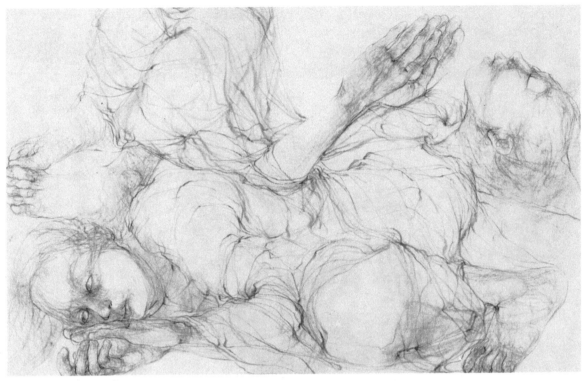

⁴² "The Girl Who Learned to Pray" (1985)

Dürer's "Betende Hände." They lift my eyes toward the serenely inspirited face of the girl who has – *in the midst of terror* – learned to pray. And is now praying.

How do I know?

My gaze is infused with her prayer.

The two figures meld into a single progressive *thought* about praying and one's doubts. Here, it seems to me that Claire is paraphrasing Graham Green's aphorism: *I measure the character of a woman's faith by the quality of her doubt.*

And so I will draw this monograph to its end by invoking my Muse's masterpiece.

Jews in the Desert.[43]

A wrenching meditation, a paragon of emphatic feminine compassion.

A complete actualization of the traceless, free-flowing, circuitous line that Claire had been developing since *Tremors.* Her streaming line no longer determined by the figures per se but by the overall "feel" (or mood) she is aiming for in composition.

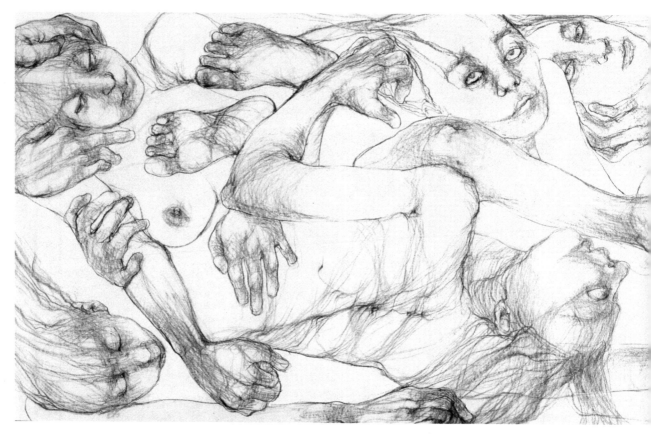

[43] "Jews In

Jews in the Desert bends figure and ground into each other to become a single field, the *desert* that is the ground of our Jewish history, if you will. Here is a complex rendering of an old Jewish thought – without a land to call our own, we were Jews lost in the desert. But here is also Claire's thinking heart, interfacing with Etty's spiritual persistence in the face of horror and terror, drawing her own sinewy lines, her own language, as *homage* to a kindred spirit. In that sense, the *interior* landscape these drawings render can be viewed as a *meta-self-portrait of Claire.*

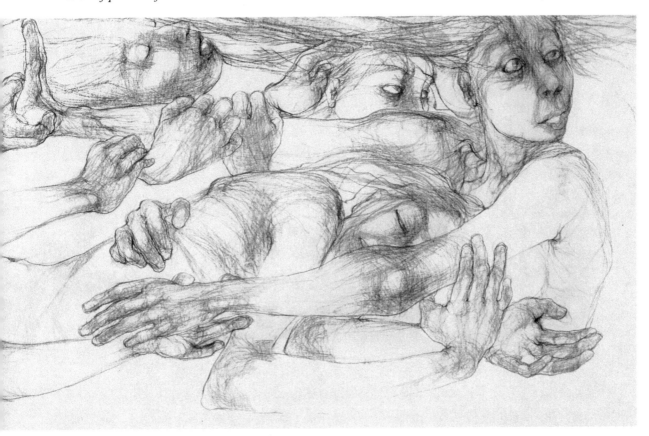

err" (1985)

From Exodus onward we Jews have worn the desert in our heart. We celebrate it every Passover, and, any which way I look at it, I see us, People of the Book, as a people of the desert who shall remain *Jews in the Desert* until the end of time.

Like Chagall's "*haimisher luftmenschen*," Claire's feminine figures float through a world of their own, alive in their own *desert* reality. Each of the *nine* faces in this work wears a specific emotion, adding to the braiding of its flowing impression.

Fifteen ephemeral hands, some interlinked, some holding on, some comforting. They establish a flow and the direction that vitalizes the drawing's dynamic and motivates the viewer to "read" its anguished faces from left to right.

In effect, the figures themselves, together, appear as ground.

They are all ground – just like the desert, it is also all ground! Ground and sky, that's it. Figures tend to melt into the desert.

Claire's symbolic *Jews in the Desert* subtly, wisely, points to the interior landscape that Jews wear in their hearts, *a thinking heart's desert*, like the emotional desert that Etty wrote about the last time she saw her father, when she realizes that the Westerbork camp itself is but an another kind of desert:

> Last time I saw my father, we went for a walk in the dusty, sandy wasteland. He is so sweet, and wonderfully resigned. Very pleasantly, calmly, and quite casually, he said, "You know, I would like to get to Poland as quickly as possible. Then it will all be over and done with and I won't have to continue with this undignified existence. After all, why should I be spared from what has happened to thousands of others?" Later we joked about our surroundings. Westerbork really is nothing but desert, despite a few lupins and campions and decorative birds that look like seagulls. "Jews in a desert, we know that sort of landscape from before." It really gets you down, having such a nice little father, you sometimes feel there is no hope at all.

As a visual corollary to a thought in Etty's writing, *Jews in the Desert* appears to me refined by its control of free fall. It is a profound drawing in Claire's unique style, with its obsessive figuration, and her singular talent for sublimating what her hand sees in a language *all her own*.

Having looked again and again at the four series of drawings I have so loved – the *Two of Us Together: Each of us alone*, *Tremors*, *Hillmother*, and *The Thinking Heart* – what comes to mind now, at the end, is how these drawings not only reveal an artist's individuation through her encounter with four aspects of *Eros*, but, as I turn the last page, the work's afterimage leaves me with a sublimated sense of Claire's soul. A soul that chose her *selective* "enframing" of reality (*pace* Heidegger) and pursued her visual *pre-consciousness* with sensitivity and a creative sensibility as a radical revealer of her own authentic view of Eros.

As these drawings show, Claire, the artist, tended to her lines the way a gardener tends to her garden. Year in, year out, travelling around the sun, through spring and summer, through growth and life, through autumn and winter, darkness and death; and in between the joy of reaching up, the sorrow of decay, and of coming back down to earth, and growing old in your own season, with your own life force, your own Eros, vivifying your art, the garden of your aesthetic freedom, *Claire. You created the masked personification of your soul. I miss you now, miss your eternally feminine laughter, always drawing me outward, and upward, to bask in an outline of your radical inner light.*[44]

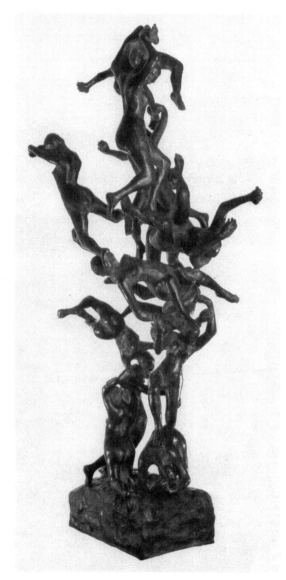

44 Totem (bronze sculpture). 117 x 58.5 x 56 cm (1992)

VI

AFTERIMAGE

A totemic taxonomy of Claire's motifs purifying as fire. Drawing *the nude*, a bared being; a dialogue between Eros the revealed and Eros the concealed. Nature's seducer, pivoting between sex and love, alive in the visual vocabulary of a pair of sinewy hands, and grounding feet, as extension of character. Her early fires. Black and white drawings, forms *signifying* emotional states. *The body as the only tactile signifier of human rootedness*; meaning we are *in* and *of* this world with a polymorphous source of pleasure, which stirs like a dance, afloat in an ether of imagination.

Absenting *terra firma*, absenting quotidian objects, marrying negative (white) space to a *gestalt* of a new—ancient icon, to invoke *a participation mystique*, like the wall carvings in the caves at Lascaux.

Presence embodied. Eros enters. The story begins, as the sheer, adamant physicality of a circular language; a body language that repeats its figuration for argument's sake, and expands its legibility through its lines in motion. If you know how to read matter and form, you know how to read body and soul, and perceive, as through a light brightly, the shadows drawn to envelope her *objet d'art* with emotive waves, and intended distortions, uttering an aesthetic freedom.

Drawing as vessel of spirit, *masking her soul* inside her figures, curved into moods, drawn to suggest, hint at, and leave *undefined* her bread of sustenance, her wine of subsistence, as well as her medium of sense, and appetite, and the transformation of sensation, *as she directs the viewer's eyes with her pre-verbal language*.

A limbic grammar evolving figurative representations of experience, love, fear, laughter, anger, the human affair, courage, despair, passion, agony, connectivity, and loneliness, as she exposes the invisible to the visible and accepts hopelessness as a means of returning to the existential body.

She speaks these drawings, like a dream *drawn into reality*, speaks about an untamed fecundity, as necessary as air and water. *No Eros, no art; no Logos, no science*. And all because of an imminent need, a desire, an itch. A vocation drawn, sometimes reasoned, sometimes irrational, other times transcendent or irrepressible, but always a patent actuality, the will to live, love, and draw for and with Eros, the *intermediary*, and finally, naturally, in the end, the singular beauty of an *oeuvre* revealed, as a truth received, as *Eros of Thanatos*.

August, 2018

Claire Wilks (1933–2017) showed her monoprints, drawings, and sculptures in Canada, the U.S., Mexico, and Europe. During the 1970s, her erotic images were rarely accepted for exhibition in conservative Toronto galleries so she sought other means to present them, such as publishing. Her books include *Two of Us Together: Each of us alone* (1982), *Tremors* (1982), *Hillmother* (1983), and *I Know Not Why the Roses Bloom* (1985), which features drawings inspired by the diaries and letters of Etty Hillesum, a Dutch Jew who died in the 1940s in Auschwitz.

Over the decades Wilks had several significant museum exhibitions of her work, most notably in the Querini Stampalia museum in Venice and the Museo del Chopo in Mexico City. It is a signal aspect of her career that writers from all over the world not only admired her drawings but, also collaborated with her, introducing her work to their home audiences. For example, the English writer, D.M. Thomas asked her to respond to his novel *The White Hotel*, which led to a series of drawings and the book *In the White Hotel* (1985). She collaborated with the Irish poet John Montague for *The Love Poems* (1992), the Serbian Miodrag Pavlović for *A Voice Locked in Stone* (1986), and was the subject of a series of poems by the Chilean surrealist Ludwig Zeller for *Totem Women* (1993). And the novelist-poet Anne Michaels has written about Wilks' monoprint works on a number of occasions.

Interestingly, an exhibition of Wilks' work in Jerusalem was introduced by the Nobel-nominated poet Yehuda Amichai, and when her work was shown in Stockholm, it was presented by the Nobel poet Tomas Tranströmer.

The first retrospective showing of Wilks' work, selected, took place in Toronto in 2018.

Photograph by Deborah Samuel